ARIZONA

INSPIRE US

GOOD
NIGHT
BOOKS

The Inspire Us series was created by Adam Gamble.
Publisher: Mark Jasper.
Associate Publisher: Apaarjeet Chopra.
Lead Photo Editor for *Arizona Inspire Us*: Adam Clear.

Dedicated to Austin Tidd.

PREFACE

Welcome to the Inspire Us series, a photographic celebration of community. Whether a local community based on place—such as a region, city, state, or country—or a dispersed community based on shared interests—like hobbies, activities, or fan groups—these books celebrate with mesmerizing images from myriad photographers.

Since 2005, Good Night Books has published a popular line of celebratory children's books based on places and themes: the Good Night Our World series. We know from firsthand experience that books can inspire children and their families to better understand and value their communities, even to take action and get involved in making our shared world a better place. Similarly, we hope the Inspire Us series will motivate you, our audience, to more deeply appreciate community.

As noted by the Japanese photographer and philosopher Daisaku Ikeda, photography is a universal language that communicates without words. Photographs transcend differences such as nationality, ethnicity, age, gender, and background,

conveying that which cannot be articulated. Perhaps this is why photography can be so emotionally expressive and evocative. It is also why we have placed the captions and credits for each photo in separate sections in the back of this book, so that words do not detract from the visuals.

In curating images for each title in this series, we use three principal criteria. First, we look for artistically impactful images that express strong ideas, perspectives, and feelings. Second, each must capture and convey something essential to the theme of the book, so that the collective result is a broad and rich exploration of the subject. Third, and most importantly, each image must have the potential to inspire.

The word inspire means to fill one with the urge or desire to feel or to do something, especially something creative. The word derives from the Latin *inspirare*, which means "to breathe into." It also shares a root with the English word "spirit," which comes from the Latin *spirare*. Thus, "to inspire" evokes the idea of "breathing life into," or "filling with spirit," or even "filling with divine spirit." We at Good Night Books believe in inspiration,

specifically the inspiration to contribute to a better world. Walt Whitman shares this sentiment sublimely in his poem "Song of the Open Road":

Gently, but with undeniable will, divesting myself of the holds that would hold me.

I inhale great draughts of space,

The east and the west are mine, and the north and the south are mine.

I am larger, better than I thought,

I did not know I held so much goodness.

All seems beautiful to me, I can repeat over to men and women,

You have done such good to me I would do the same to you.

We thank you for joining us in the Inspire Us series. We wish you the best of journeys.

—Good Night Books

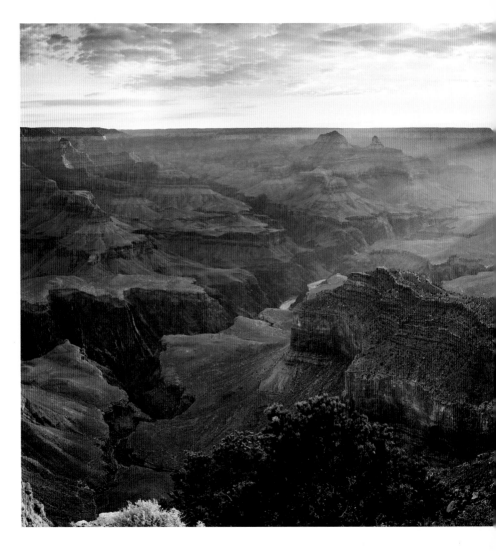

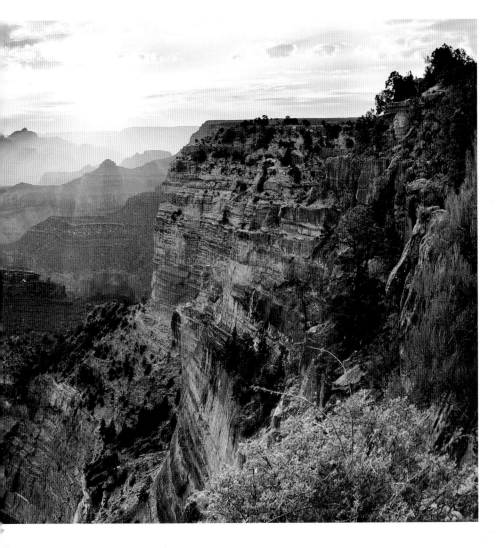

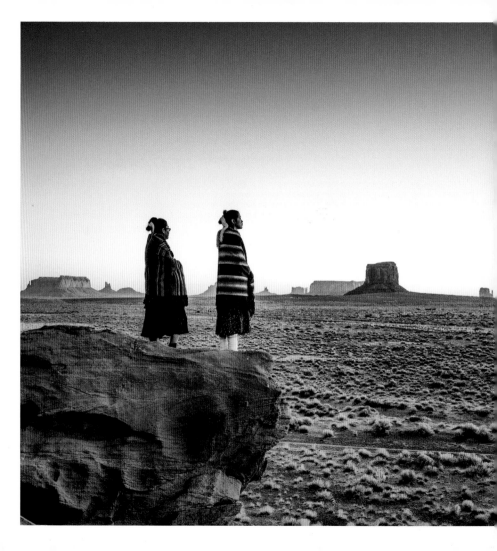

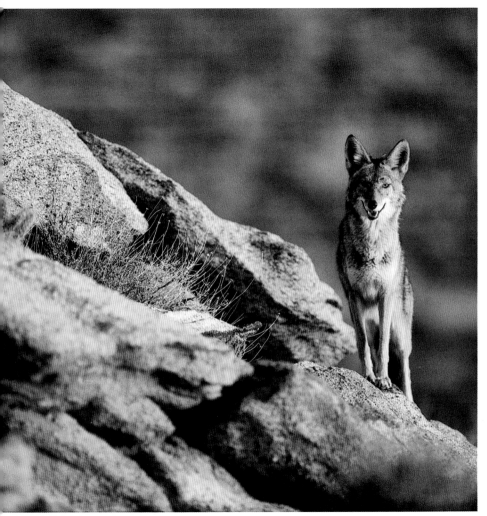

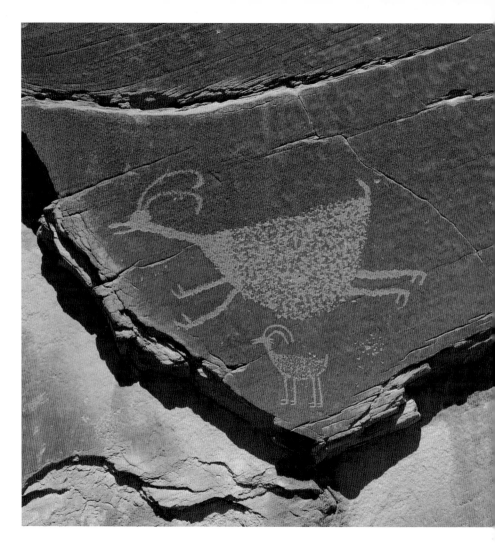

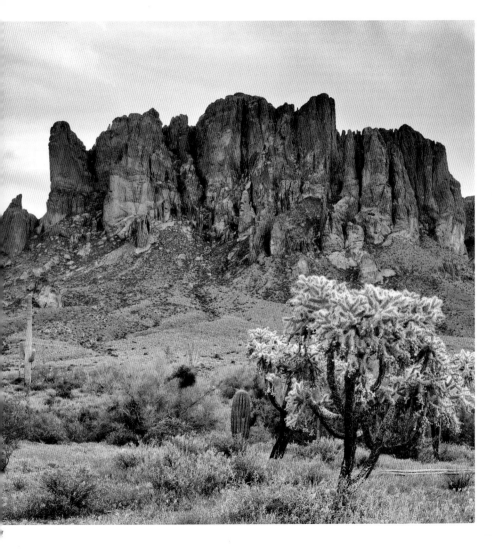

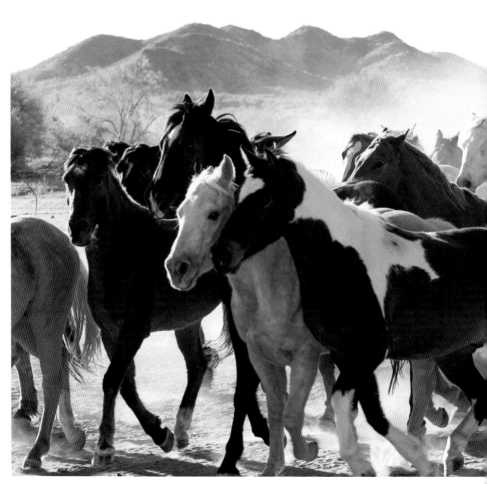

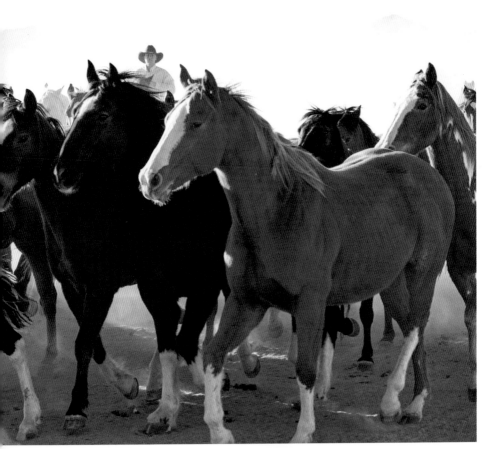

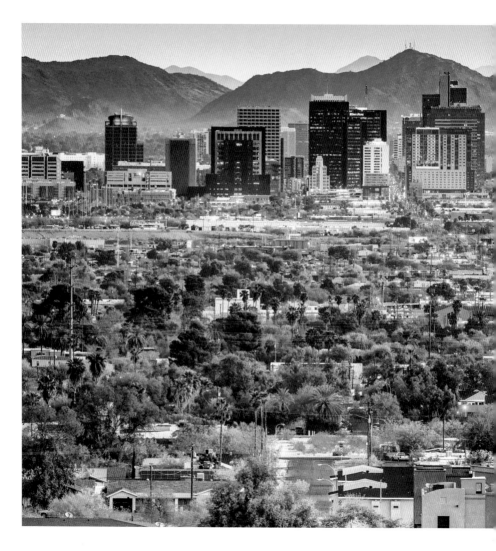

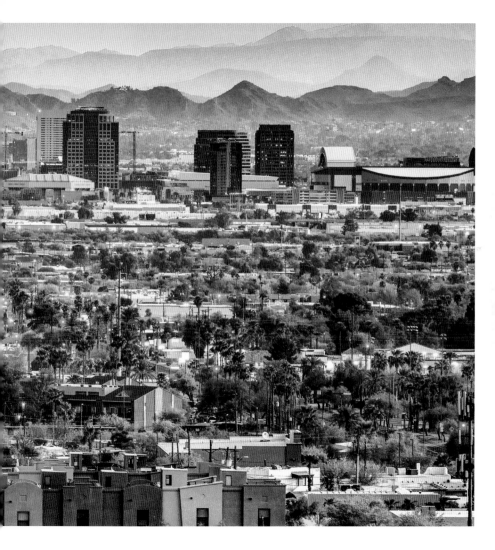

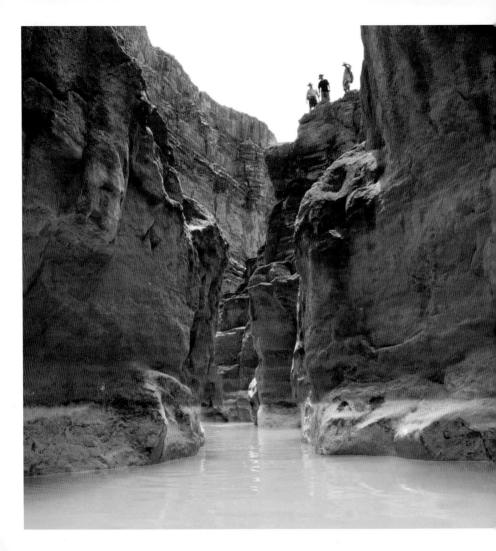

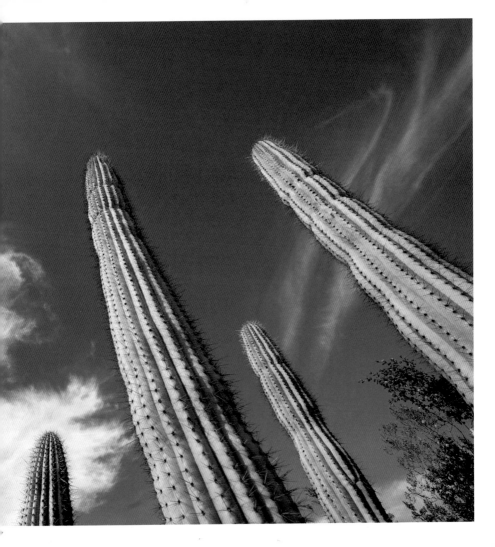

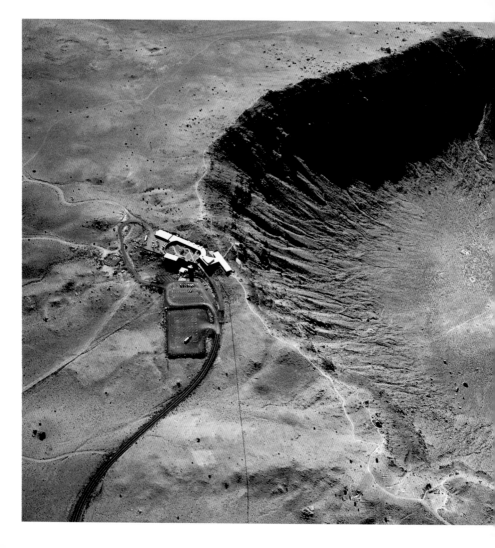

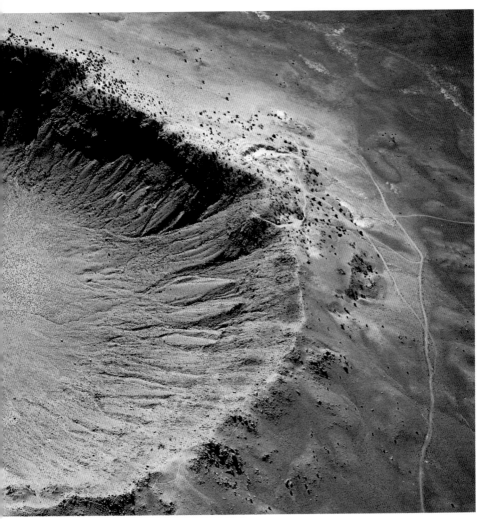

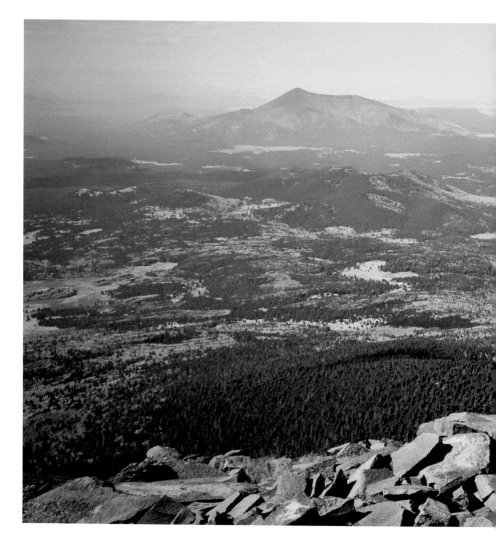

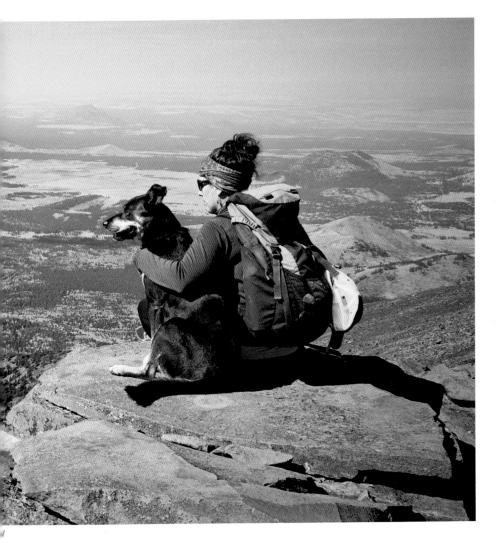

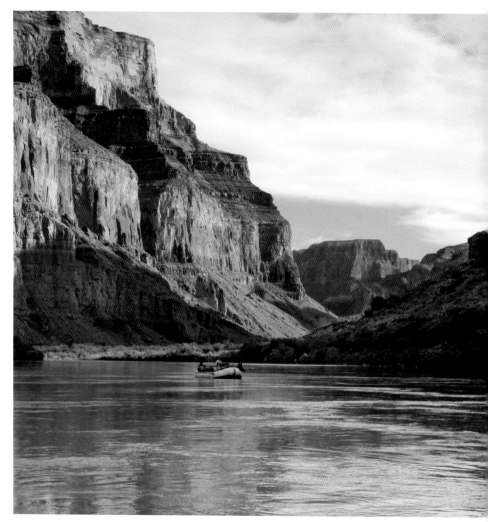

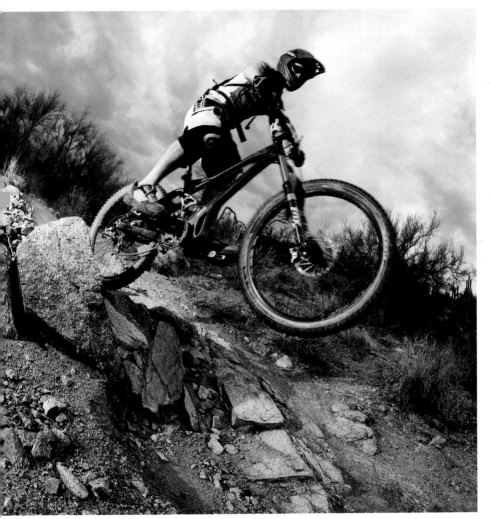

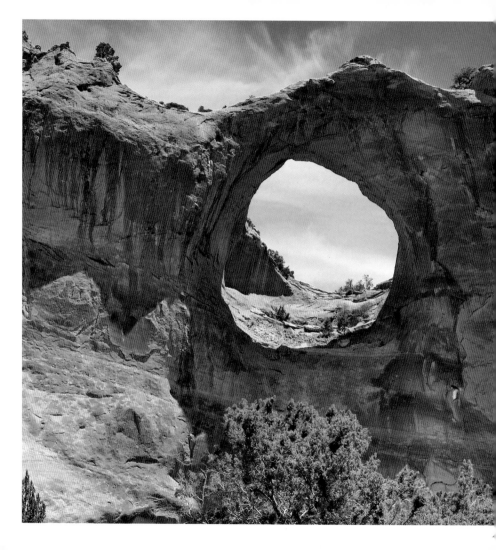

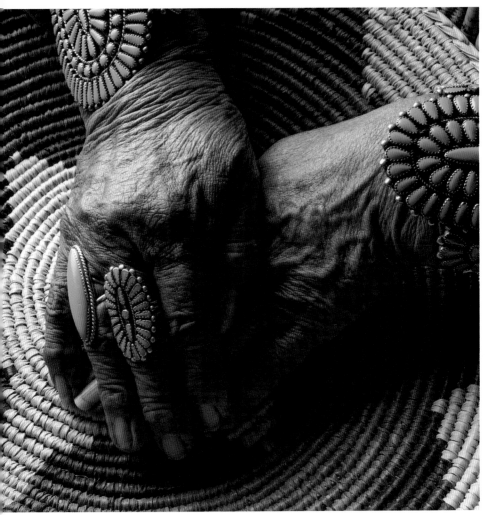

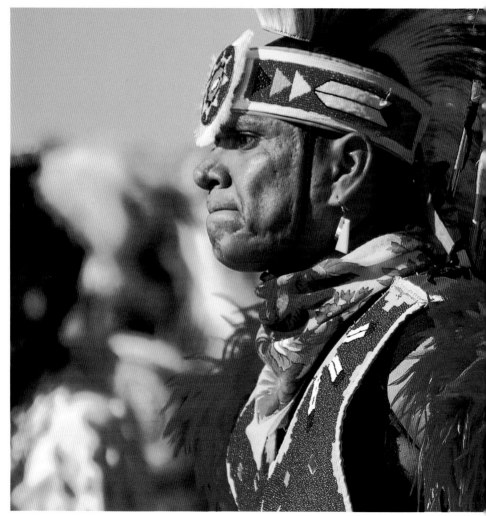

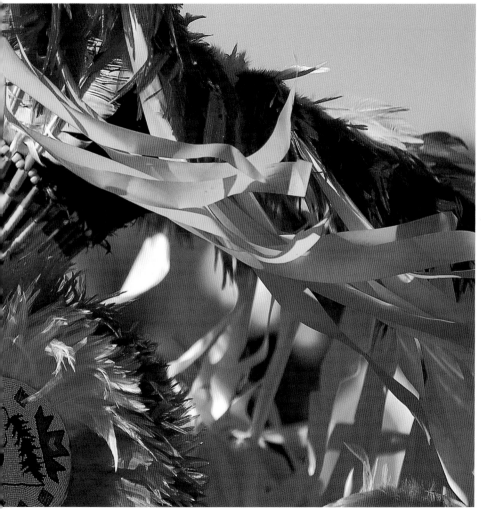

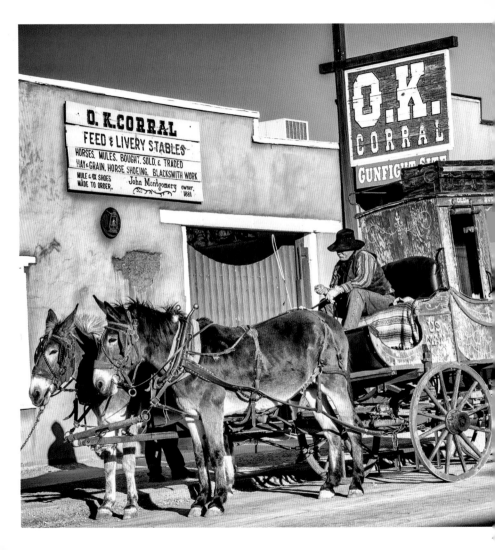

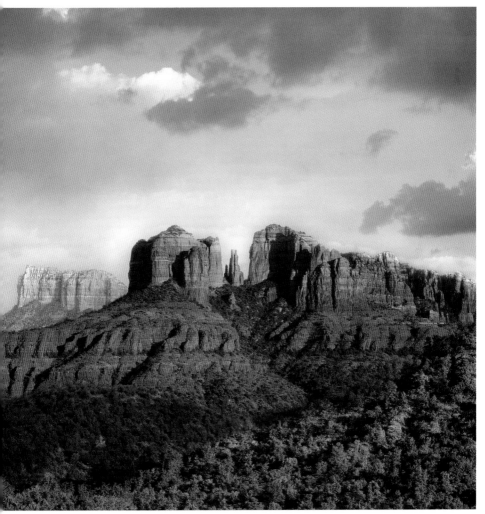

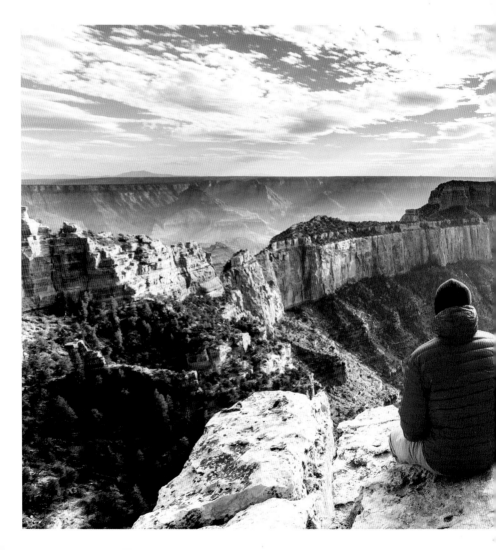

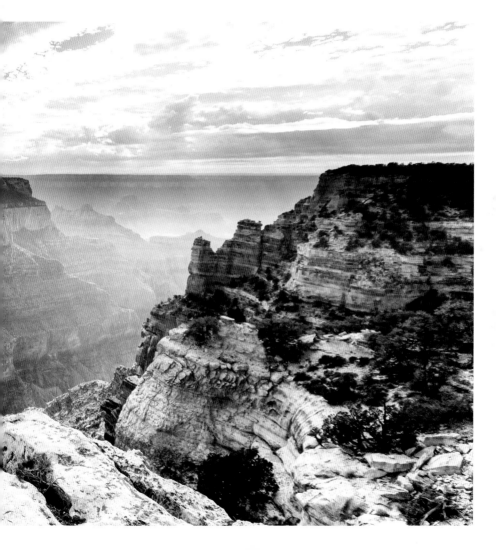

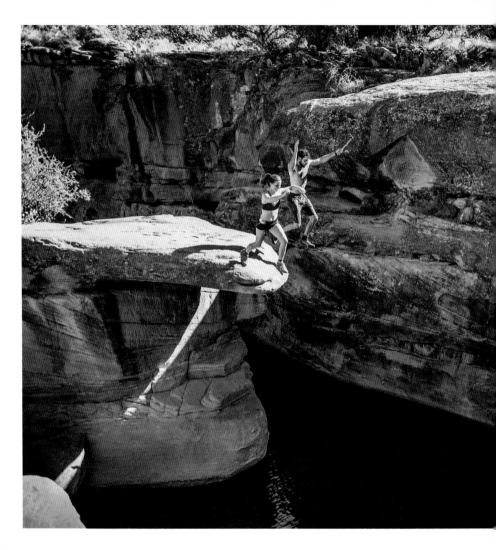

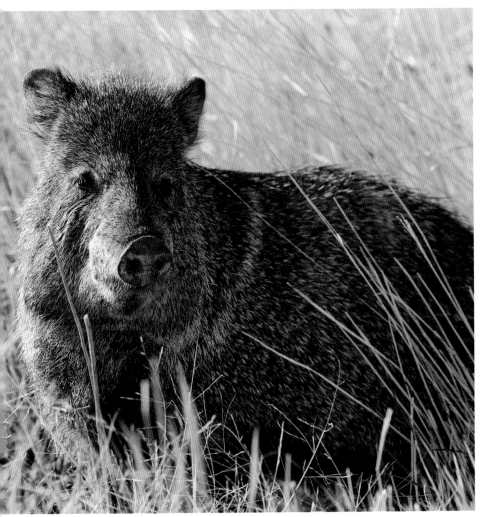

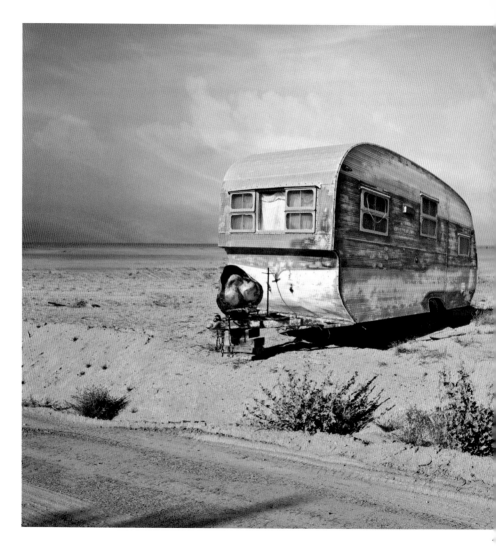

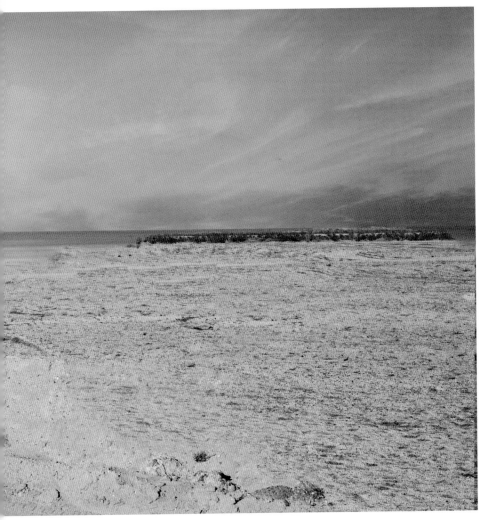

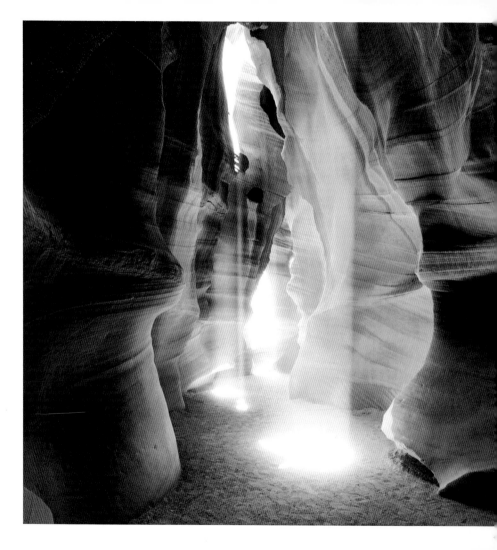

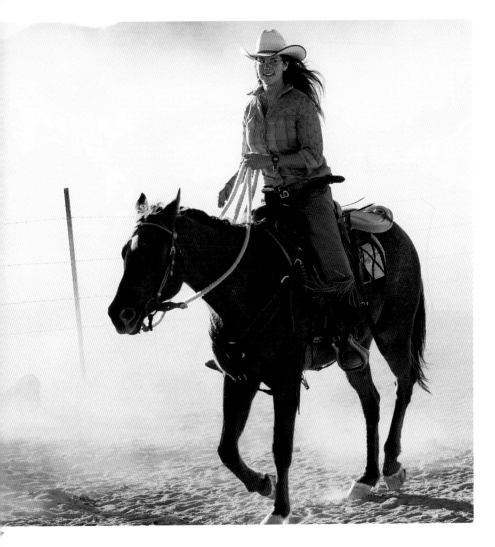

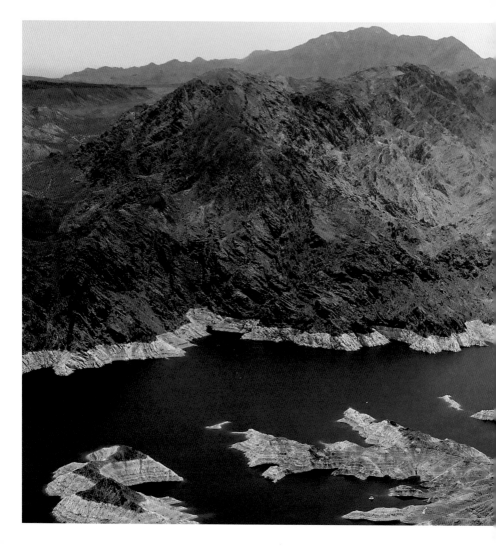

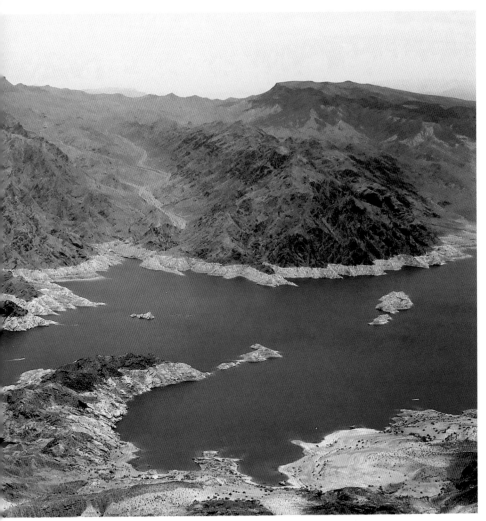

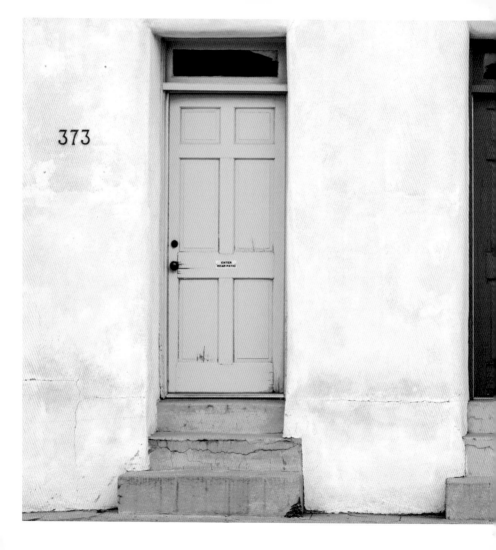

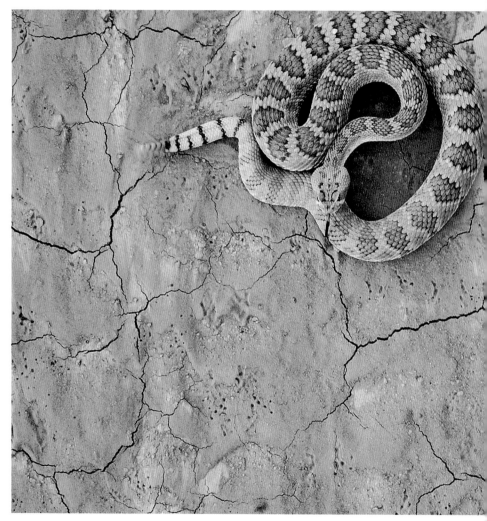

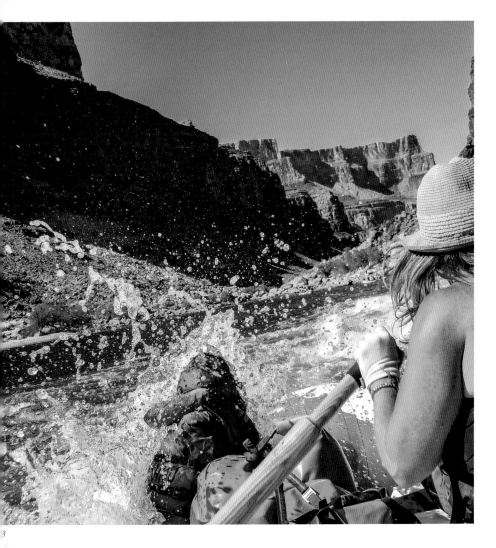

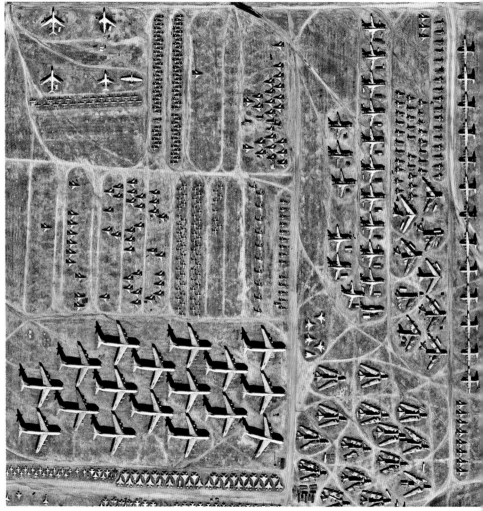

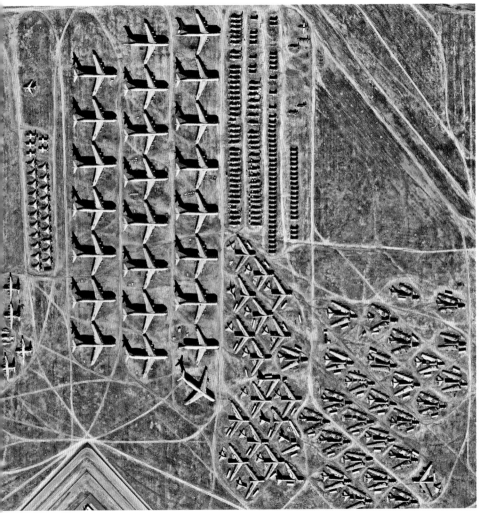

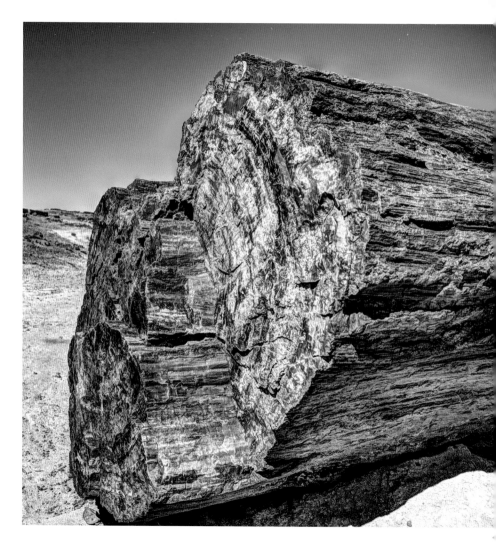

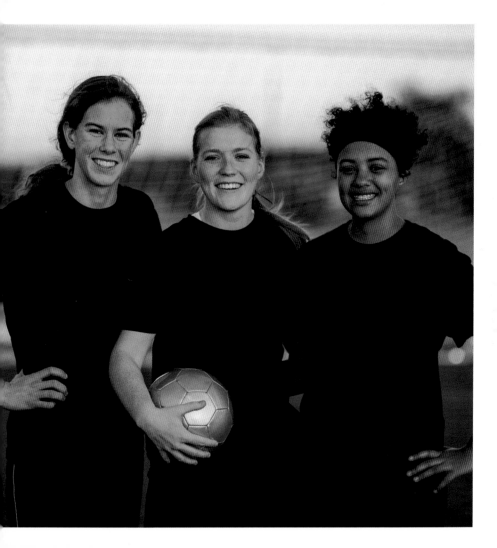

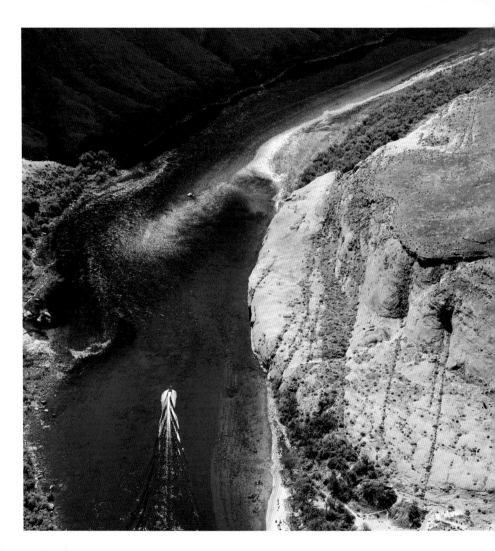

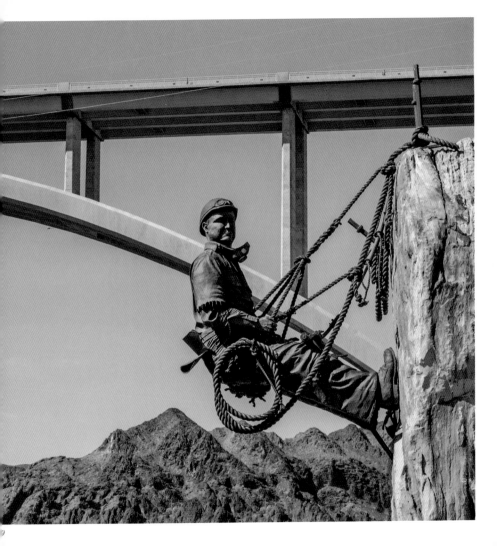

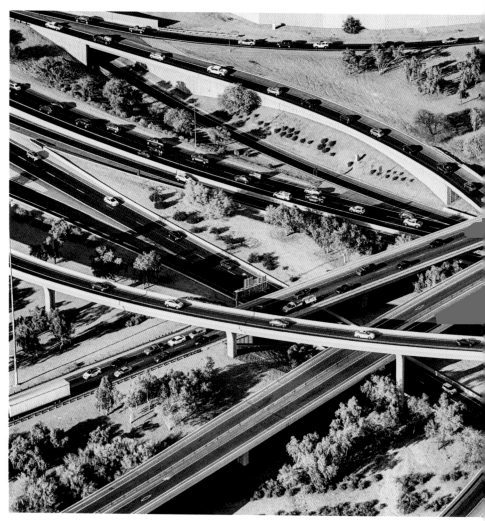

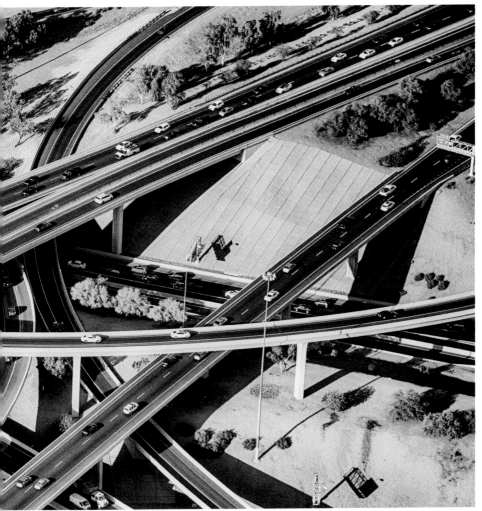

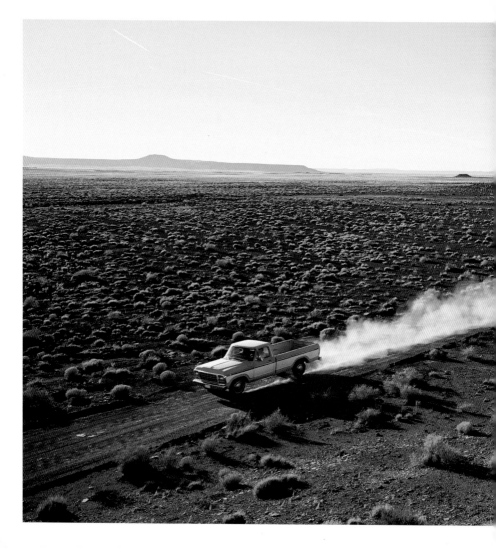

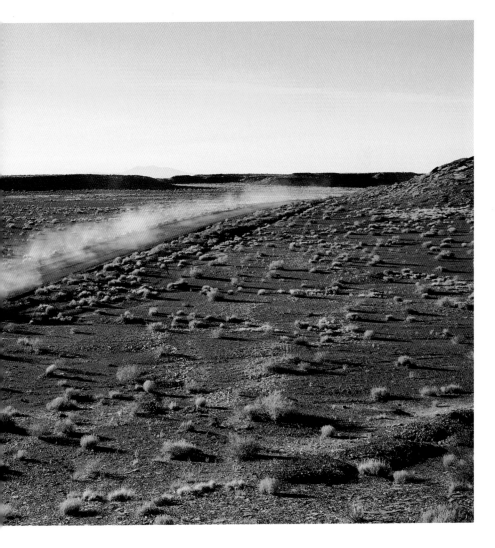

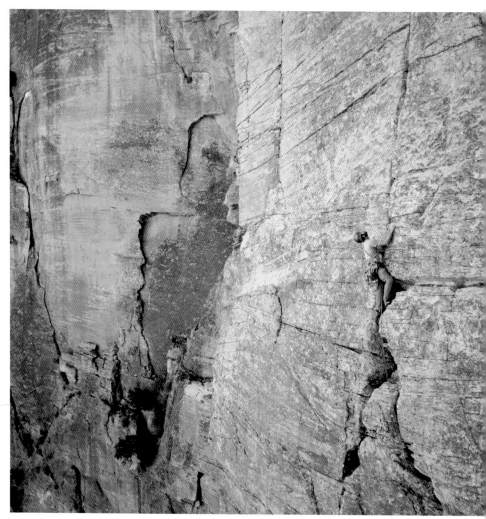

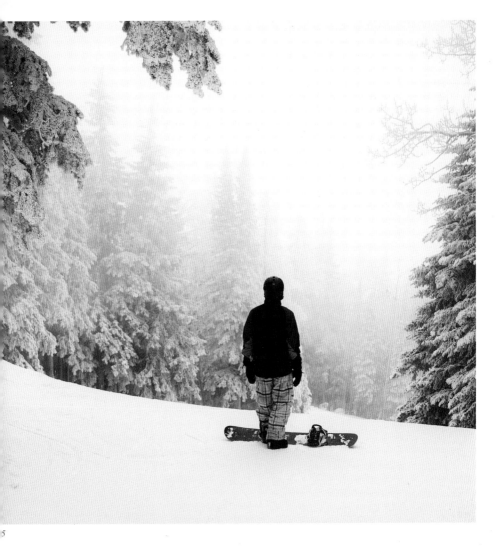

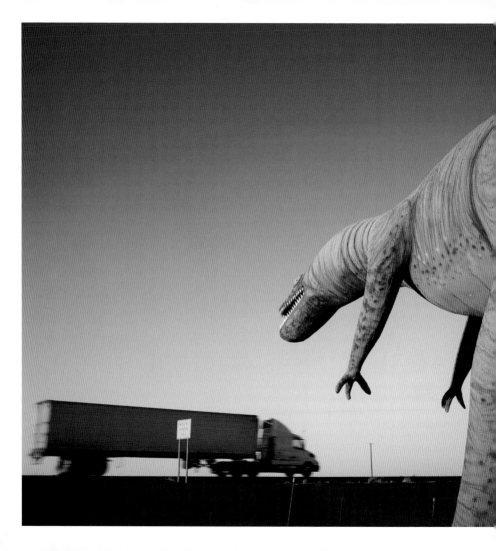

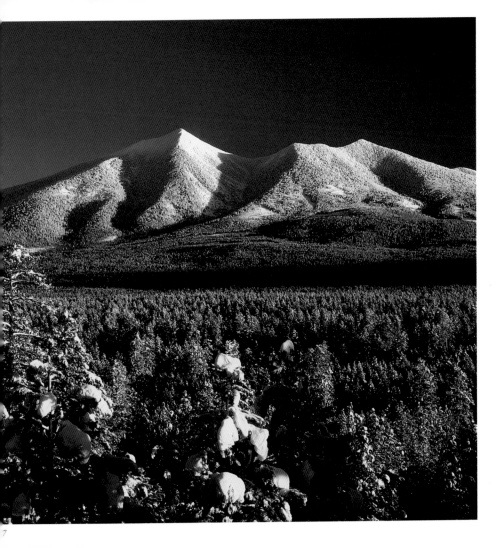

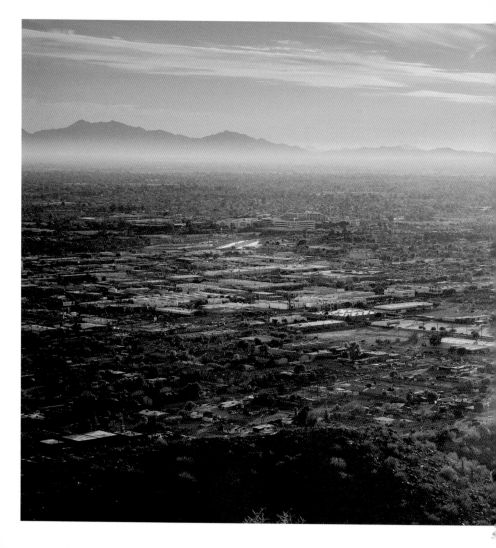

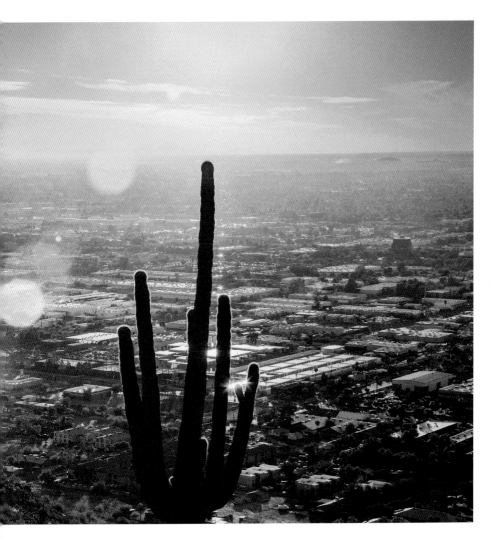

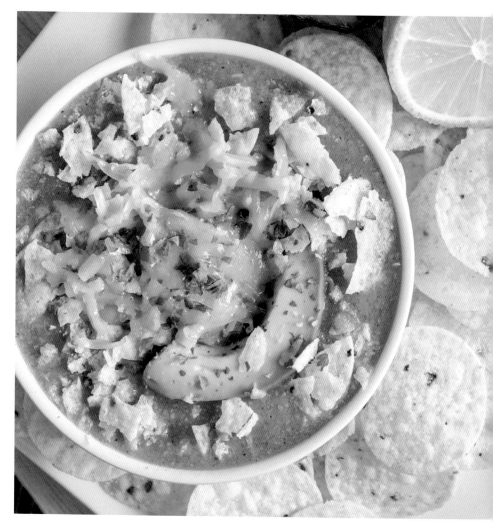

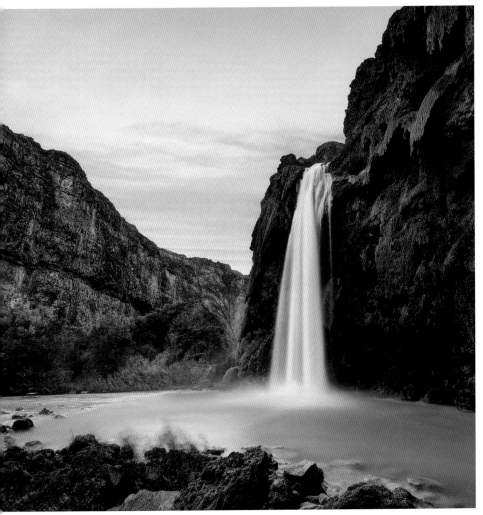

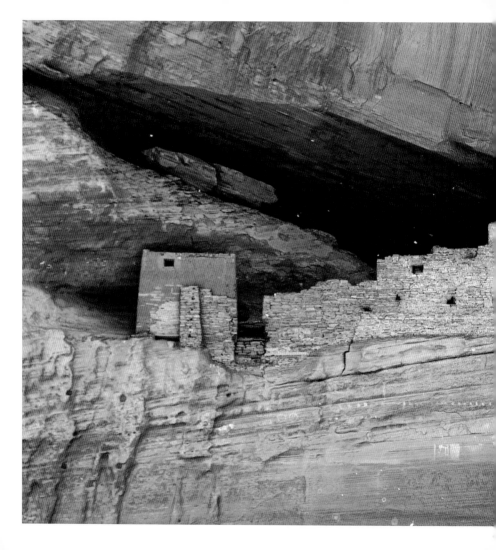

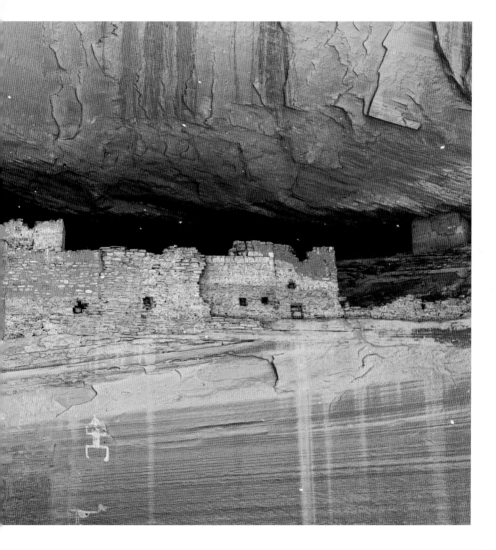

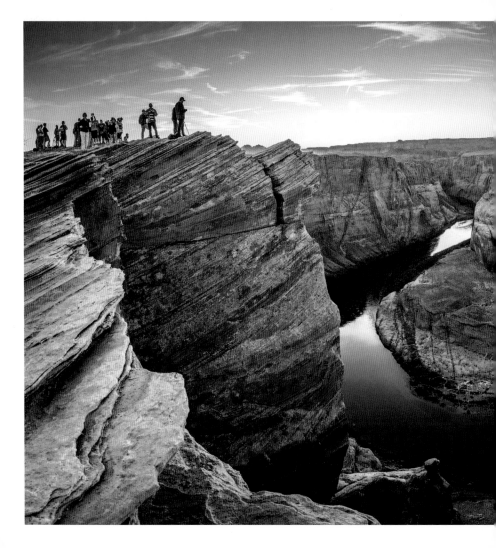

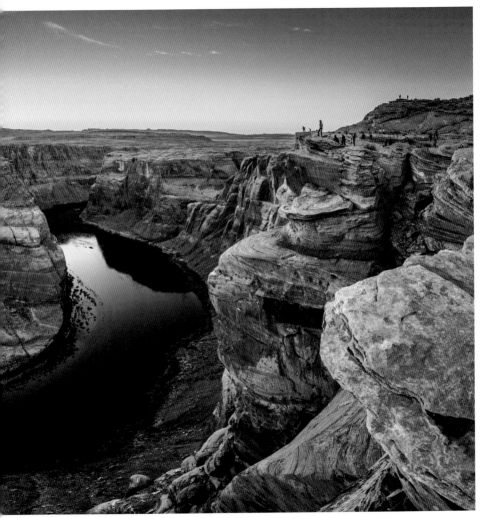

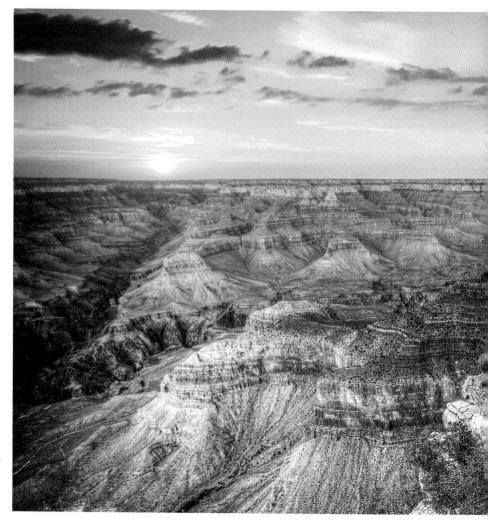

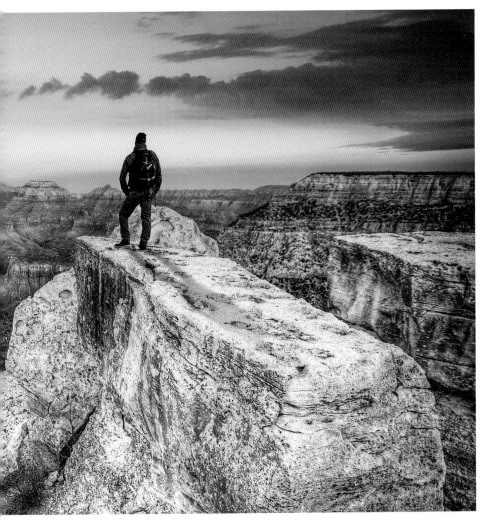

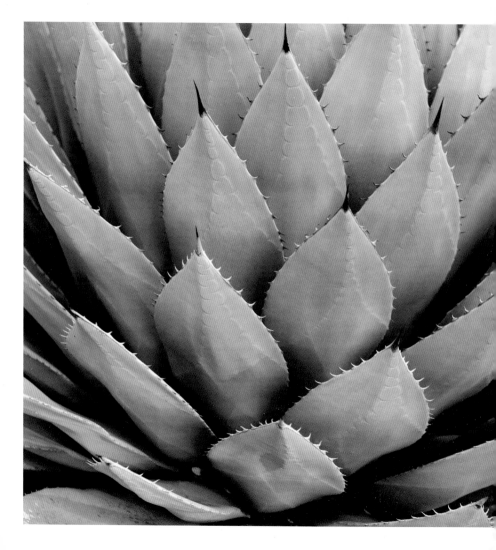

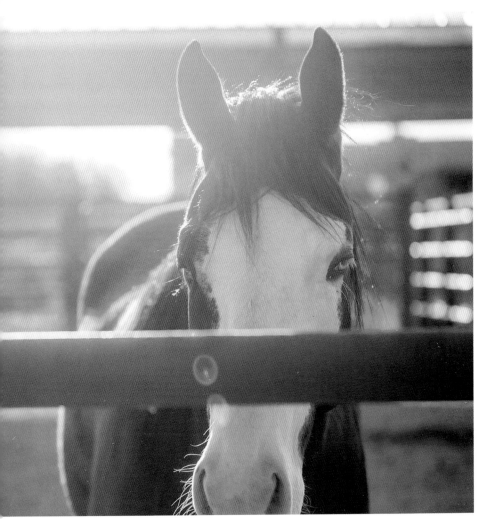

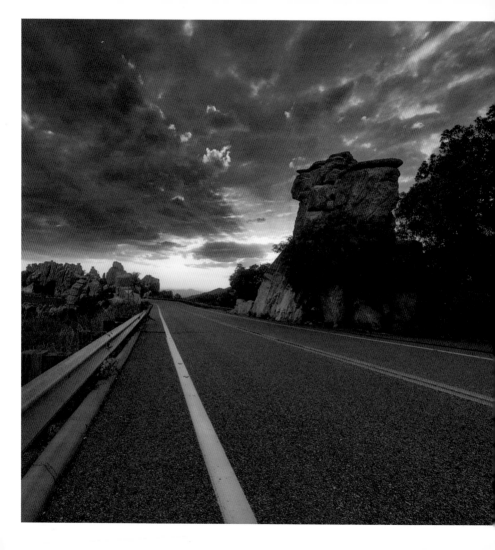

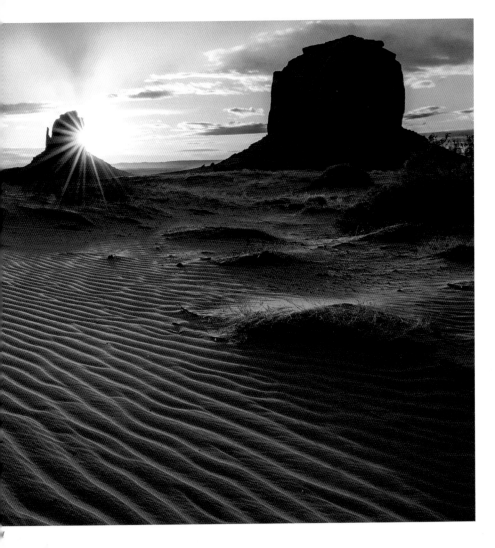

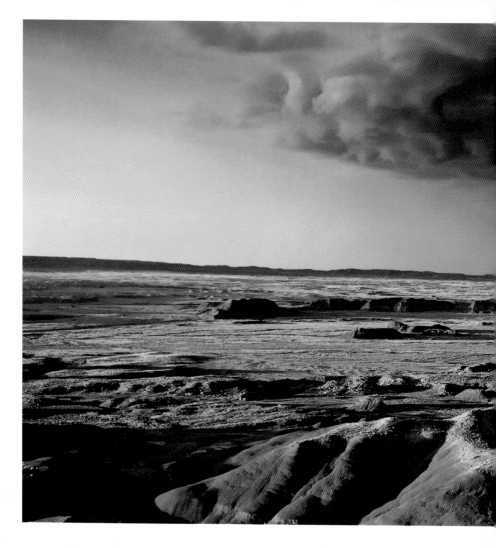

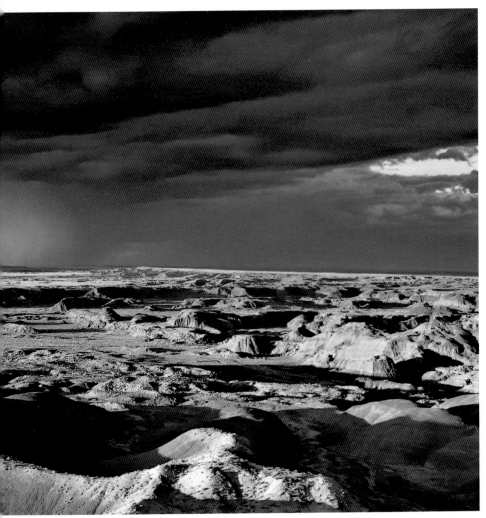

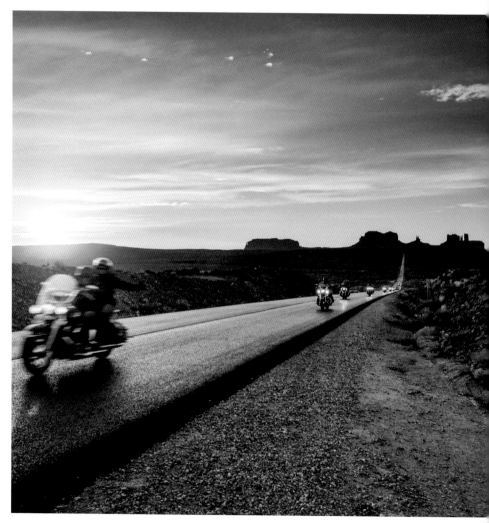

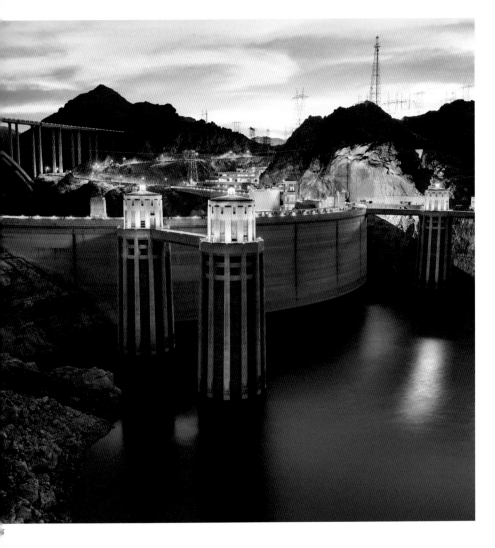

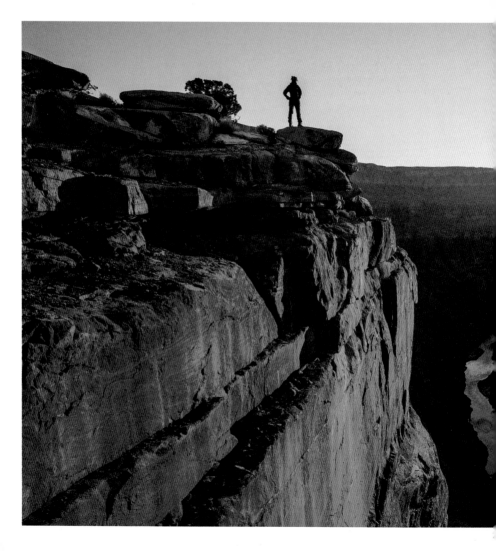

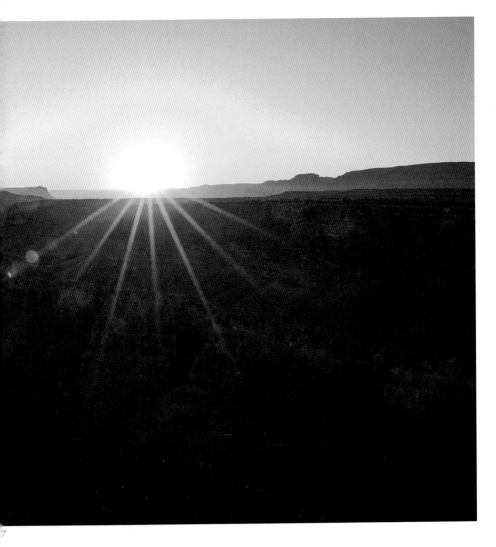

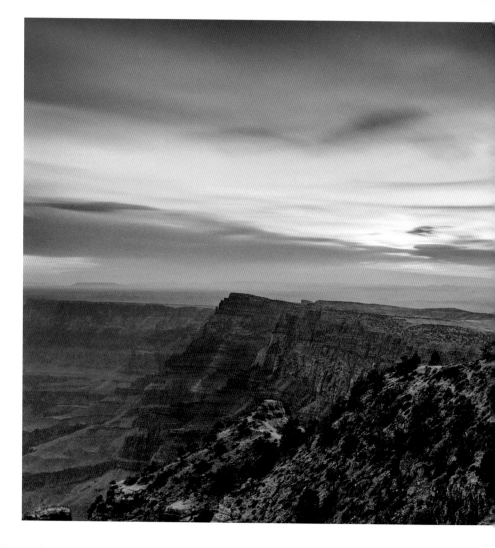

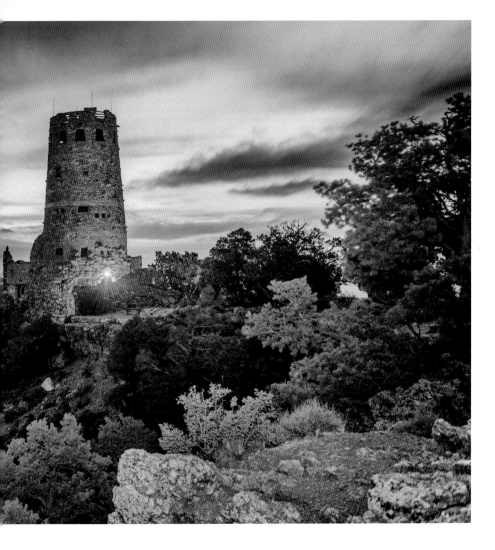

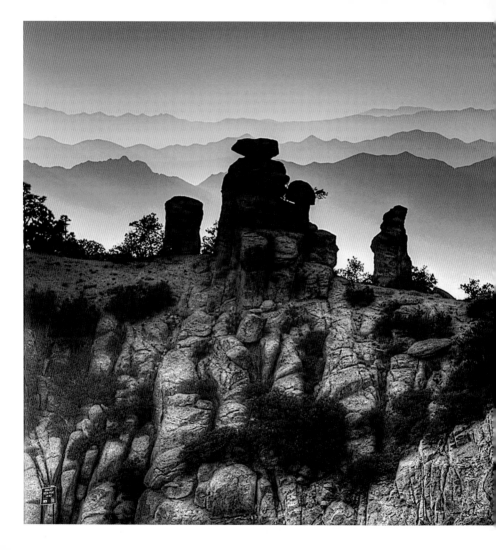

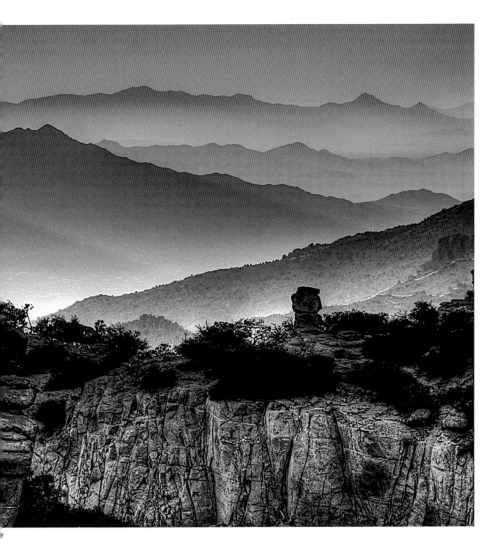

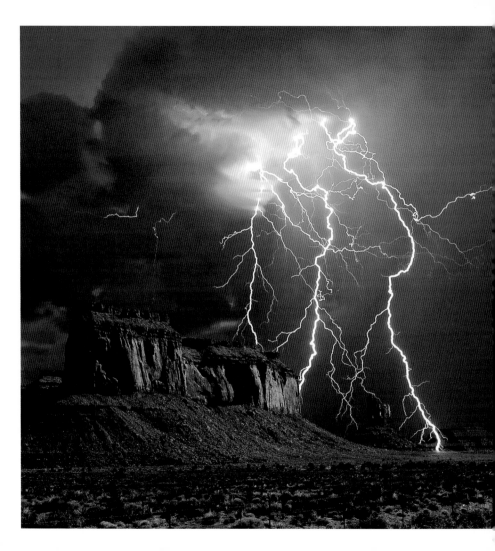

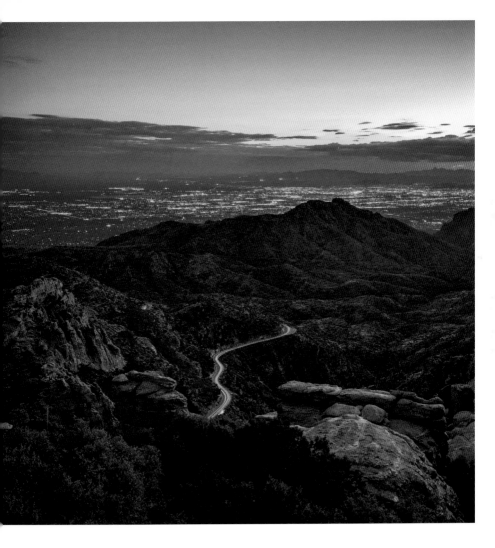

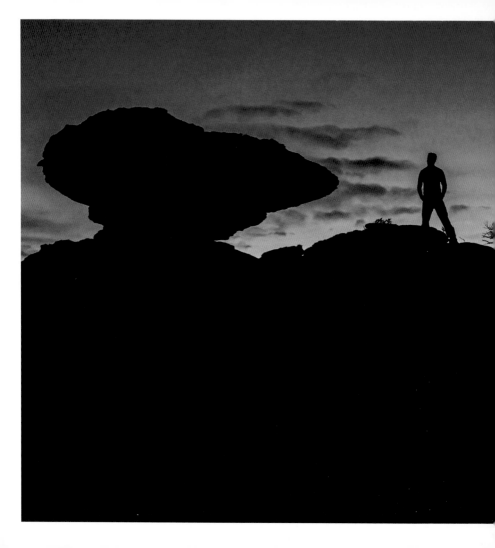

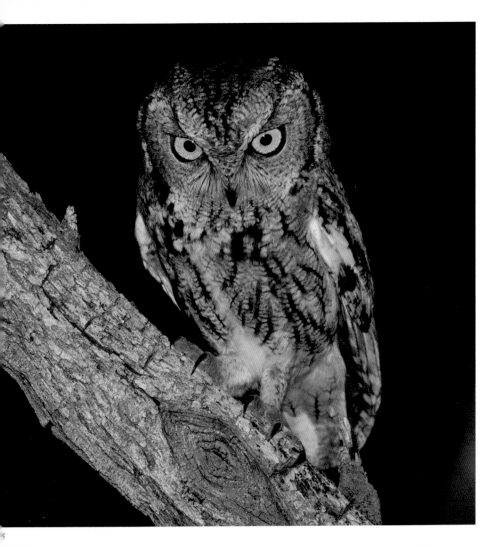

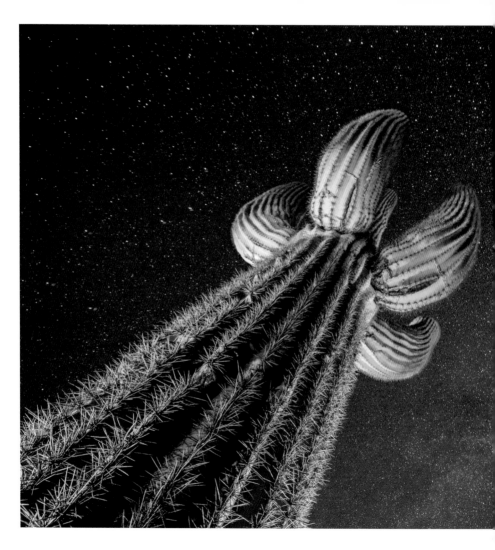

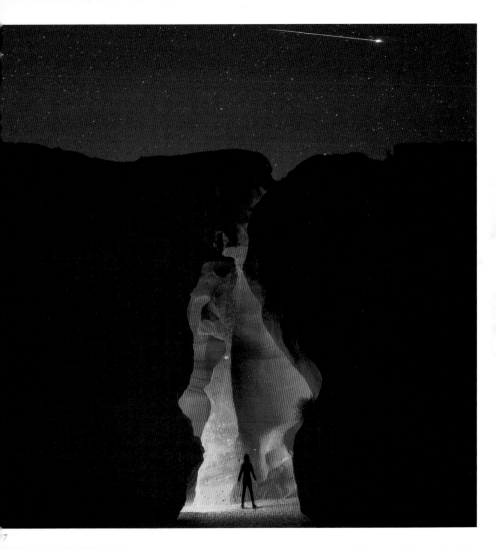

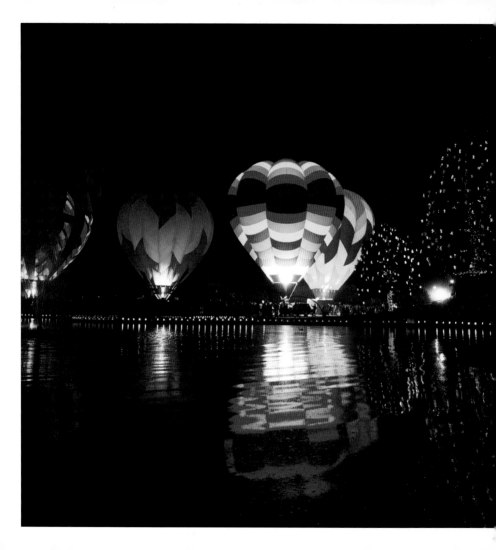

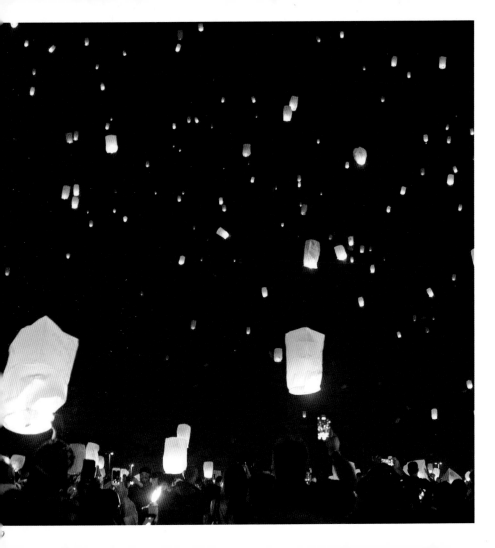

CAPTIONS

Front Cover: Sunset at Grand Canyon National Park.

Back Cover: Wild horses in Monument Valley.

Endsheets: Dried hot peppers hanging from a post.

6-7: Sunrise emerges over the Grand Canyon.

8: Two Navajo sisters stand on a rocky butte in Monument Valley Tribal Park.

9: A coyote stands on a rock ledge in the Sonoran Desert.

10: Ancient rock art in Navajo, Arizona.

11: The Superstition Mountains surrounded by saguaro cacti at sunset.

12-13: A rancher herds horses.

14-15: The Phoenix cityscape at dusk.

16: The mouth of Havasu Creek in the Grand Canyon.

17: A group of organ pipe cactus in the Organ Pipe National Monument.

18-19: The Barringer Meteor impact crater near Flagstaff, Arizona.

20-21: A hiker and her dog enjoy the view on Humphreys Peak in the Kachina Peaks Wilderness area.

22: Rafters tour the Colorado River.

23: A mountain biker takes on a steep rocky path at South Mountain Park and Preserve.

24: Window Rock, an iconic landmark in the Navajo Nation's capital city of the same name.

25: A Navajo woman adorned with traditional turquoise jewelry.

26-27: Dancers participate in the Annual Red Mountain Eagle Pow-Wow, presented by the Salt River Pima-Maricopa Indian Community in Scottsdale, Arizona.

28: A stagecoach is hitched in front of the historic O.K. Corral in Tombstone, Arizona.

29: A rock formation in Sedona, Arizona, at dusk.

30-31: A hiker takes in the view at Grand Canyon National Park.

32: A couple jump into a lake in the Wet Beaver Wilderness, an area in the Coconino National Forest.

33: A javelina (or peccary) basks in a field.

34-35: A trailer in the Arizona desert.

36: Light dances through Upper Antelope Canyon in Page, Arizona.

37: A rancher rides her horse.

38-39: An aerial view of the Lake Mead National Recreation Area, Arizona.

40-41: The colorful doors of historic adobe homes in Tucson, Arizona.

42: A Mojave rattlesnake coils in the desert.

43: A woman rafts through the Grand Canyon.

44-45: An aerial view of the largest aircraft boneyard in the world, located at Davis-Mothan Air Force Base in Tuscon, Arizona.

46: Petrified wood displaying multiple colors in the Petrified Forest National Park.

47: Three Arizona high school soccer players in practice uniforms pause for a candid moment on the pitch.

48: A boat moves down the Colorado River on a sunny day.

49: A bronze statue of high scaler Joe Kline at the Hoover Dam.

50-51: An aerial view of the Phoenix Freeway Interchange.

52-53: A truck rides through the desert on Route 66 in Arizona.

54: A rock climber scales a mountain in Sedona, Arizona.

55: A snowboarder looks down his path as fog rolls in.

56: A tractor trailer passes a large dinosaur model in Holbrook, Arizona.

57: The San Francisco Peaks of Arizona, lightly dusted with snow.

58-59: Cacti soak up the sun in Piestawa Peak above the city of Phoenix, Arizona.

60: A bowl of chicken enchilada soup with avocado and tortilla chips.

61: Havasu Falls at sunset.

62-63: White House Ruins, the historic Anasazi dwellings built into a sandstone cliff in the Canyon de Chelly National Monument.

64-65: Visitors enjoy the view of Horseshoe Bend at sunset.

66-67: A hiker enjoys the Grand Canyon view at sunrise.

68: An aloe plant thrives in the climate of Tucson, Arizona.

69: A horse in Scottsdale, Arizona.

70: A sunset view of the roadway with rock formations in Tucson, Arizona.

71: A stunning view of the textured sands of Monument Valley, Arizona, at sunrise.

72-73: A storm approaches the Painted Desert of the Petrified Forest National Park in Arizona.

74: Bikers ride through Navajo Tribal Park in Arizona.

75: The Hoover Dam, lit up at dusk.

76-77: A hiker stands at Toroweap Overlook and gazes over the Grand Canyon and Colorado River.

78-79: The Desert View Watchtower on the South Rim of the Grand Canyon in Arizona.

80-81: A view from Mt. Lemmon, near Tucson, Arizona.

82: A lightning storm touches ground at the Eagle Mesa in Monument Valley, Arizona.

83: A view of Tucson, Arizona, from Mt. Lemmon at the edge of sunset.

84: A man stands on a rock formation at sunset.

85: A western screech owl sits on a perch in the Arizona desert.

86: A starlit view of a large saguaro cactus.

87: Upper Antelope Canyon beneath the stars.

88: Illuminated hot air balloons during holiday season festivities.

89: Paper lanterns lift into the twilight sky during a festival at Lake Pleasant in Phoenix, Arizona.

CREDITS

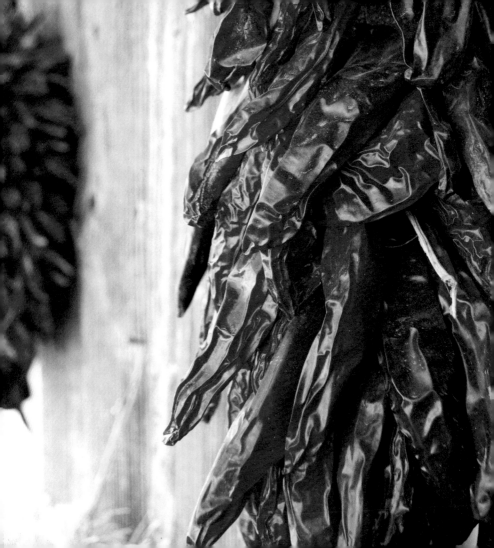